VERY LITTLE IS NEEDAD TO MAKE A HAPPY LIFE, IT IS ALL WITHIN YOURSE LF, IN YOUR WAY OF THINKING

..................MARCUS AURELIUS..................

www.ingramcontent.com/pod-product-compliance
Lightning Source LLC
Chambersburg PA
CBHW070332190526
45169CB00005B/1858